T0079699

CONRAD FELIXMÜLLER

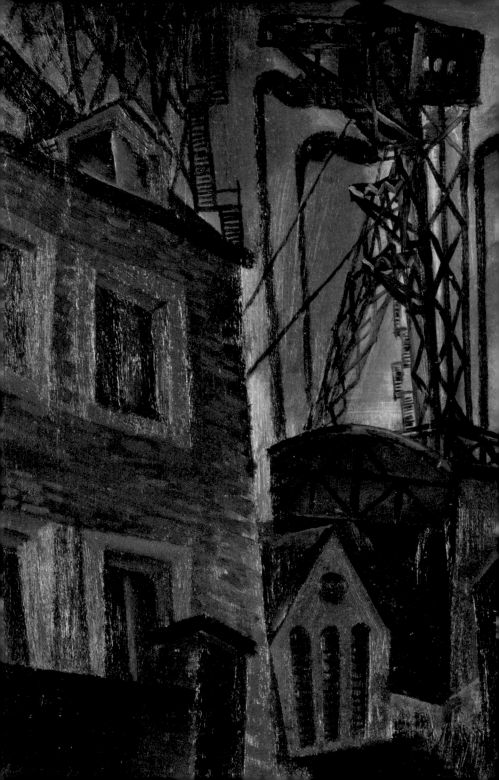

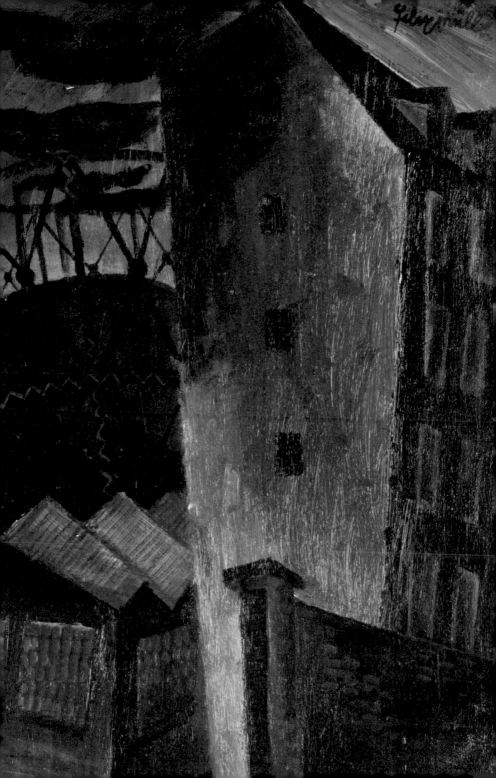

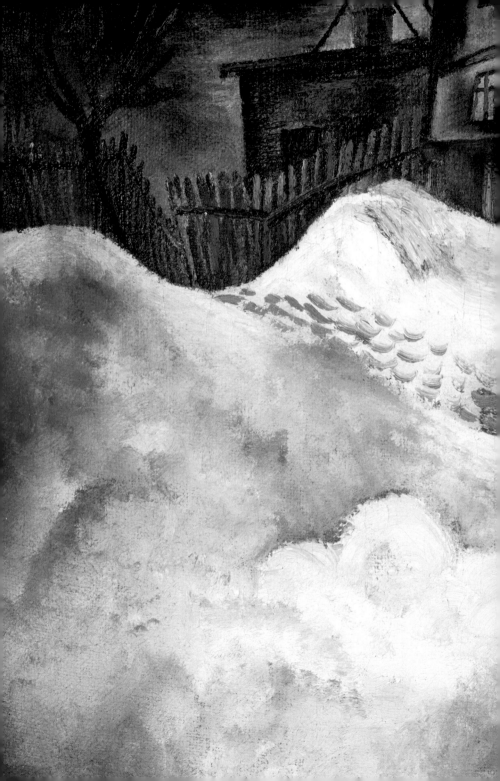

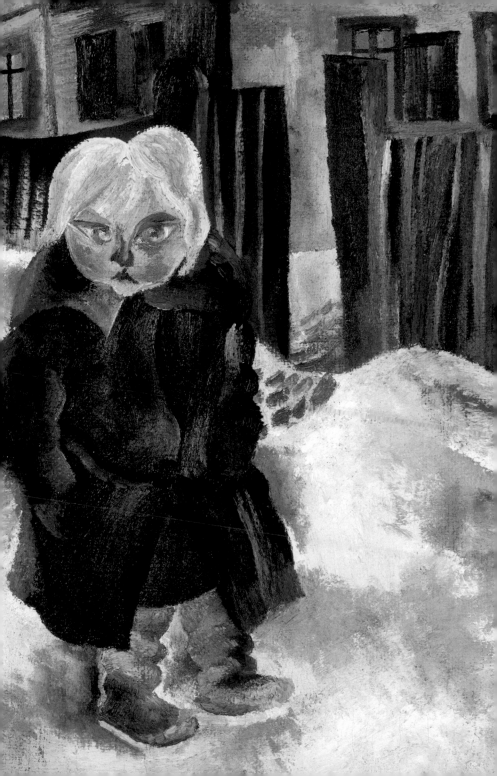

CONRAD
FELIXMÜLLER

David Riedel

HIRMER

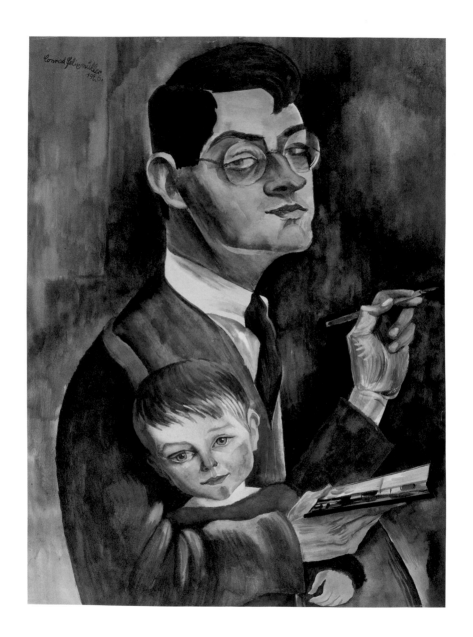

CONRAD FELIXMÜLLER
Self-Portrait with The Artist's Son Titus, 1926, watercolour on paper, 72 × 53 cm
Stiftung Schleswig-Holsteinische Landesmuseen Schloss Gottorf, Silesia

CONTENTS

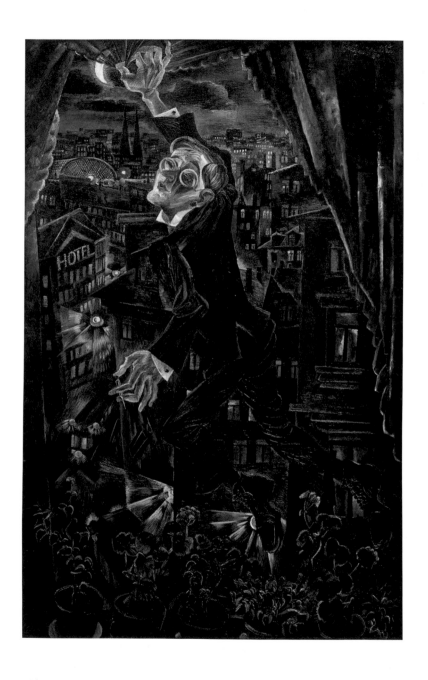

1 *The Death of the Writer Walter Rheiner*, 1925, oil on canvas, 180.3 × 115.5 cm, private collection

"IN HIS ART HE DELIBERATELY FOCUSES ON MAN" ON THE WORK OF THE PAINTER AND GRAPHIC ARTIST CONRAD FELIXMÜLLER

David Riedel

The Death of the Writer Walter Rheiner (1) is an artistic vision of a tragic suicide and Conrad Felixmüller's pictorial memorial to a friend. He had met Walter Rheiner in his home town Dresden during the First World War. The two men shared artistic and revolutionary ideas. Felixmüller illustrated his friend's novella *Cocaine*, published in 1918, the story of an addict's agony between euphoria and crashing – and an anticipation of its author's fate. In the painting Rheiner appears to float in the night sky, the syringe with the overdose of the drug in his hand, beneath him eerily but beautifully lit the canyons of the metropolis Rheiner had so often described. Deeply moved by the fate of his friend, Felixmüller took up once again in this picture the expressiveness and colouring of earlier works. He had long since turned away from Expressionism, that "wild experiment that amusingly brought me success, a name and money."[1] Doubtless for

this reason the painting was interpreted as if the artist wished to "say a last farewell to an epoch that had finally ended."[2]

Throughout his long career, Felixmüller repeatedly reflected on his own life and work, from the 1927 etching series *A Painter's Life* to the *Recollections* woodcuts from the late 1960s, as well as in a considerable number of written statements. Whereas in his old age these mostly amounted to a retrospective look at what he had accomplished, with texts like his "Postulate" from 1917 or the essay "The Proletarian (Pönnecke)" from 1920, Felixmüller had self-confidently spelled out his convictions as an artist. Such confessions accompanied the seven decades of his life's work. His œuvre consists of more than 1,600 paintings, more than 700 graphic works, and a still uncertain number of watercolours and drawings, as well as stage sets, illustrations and a small number of sculptures.[3]

The work of the artist, who was born in 1897, is closely linked with his biography. During his life he experienced five political systems and two world wars. He was sensitive to social and political developments in the world and reflected their consequences in his work; he has quite rightly been described as a "seismograph."[4] As an artist he felt he had a special obligation, as he affirmed in the frequently quoted "Art is a historical matter because it is the expression of human society; the aesthetic element is of secondary importance."[5]

"STUDIED FAST IN ORDER TO GIVE FORM TO WHAT MOVED ME"

Realistic early drawings of his parents and his sister (3) and first self-taught etchings produced with zinc plates mark the beginning of Conrad Felixmüller's lifelong devotion to the portrait. His talent was recognised and encouraged early on, and he soon advanced from the drawing board to the easel. During a stay in the Willingshausen artists' colony in the summer of 1913 he produced his first proper paintings in an Impressionist-influenced plein-air style promoted by his teacher Carl Bantzer. Back in his Dresden studio, he portrayed the painter Marianne Britze (2) in lively colours and vigorous brush strokes as a self-confident young woman gazing at him provocatively. His desire to free himself from academic conventions was reinforced by his encounter with the Westphalian painter

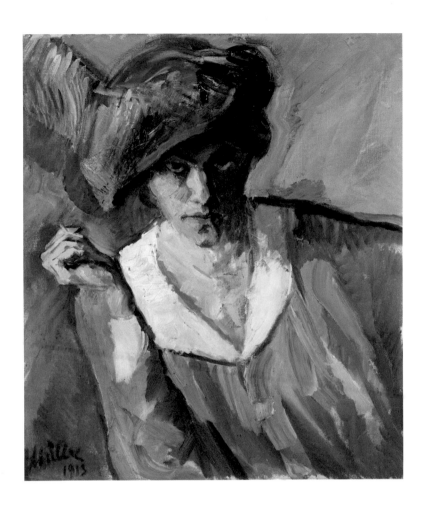

2 *Portrait of Hanna*, 1912, pencil on paper, 51 × 40 cm, private collection

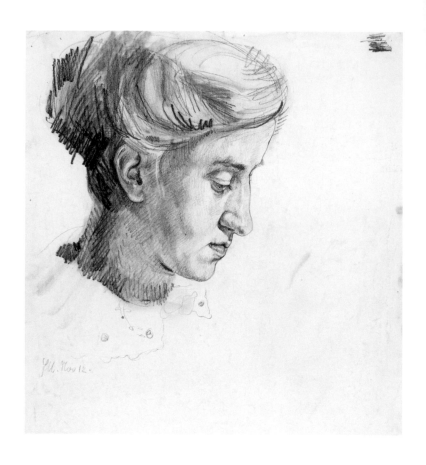

3 *Portrait of Marianne Britze*, 1913, oil on canvas, 67 × 58 cm
Nationalgalerie, Staatliche Museen zu Berlin

4 *My Sister Hanna*, oil on canvas, 70 × 65 cm, Bunte Collection

Peter August Böckstiegel. The two men became close friends, "intoxicated with the good fortune of being painters."[6] Felixmüller was fascinated not only by Böckstiegel's powerfully executed painting bursting with expressive colouring, but also by the self-confidence of the latter, who was eight years his senior: "He mostly threw his loud colours on the canvas with a palette knife, thereby slapping Dresden's fine-toned painting culture in the face."[7] It was not long before Felixmüller was also painting portraits in which he managed to apply Expressionist ideas independently and with formal clarity (4): his woodcuts illustrating Arnold Schönberg's melodrama *Pierre Lunaire* from 1913 had already been inspired by "Die Brücke"

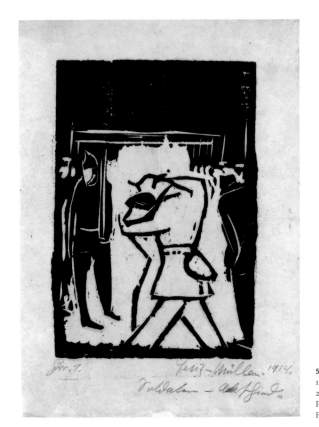

5 *Soldier's Farewell*,
1914, woodcut
20.5 × 14 cm
P. A. Böckstiegel-
Freundeskreis

prints. Felixmüller promptly withdrew from the Academy; and then came
the outbreak of the First World War. Unlike some of his artist friends, he
was not called up at first, but in a small-format woodcut (5) one senses the
17-year-old's far from euphoric attitude, in contrast to many of his contem-
poraries. In *Soldier's Farewell* the artist focuses on an embracing couple,
sketching them with sparse outlines and setting them apart from the world
by a harsh light, and with soldiers waiting in the background. Before long
Felixmüller had reached the point where he could reproduce the essence of
a scene and fill it with expression – "as happened, so seen, so pictured."[8]

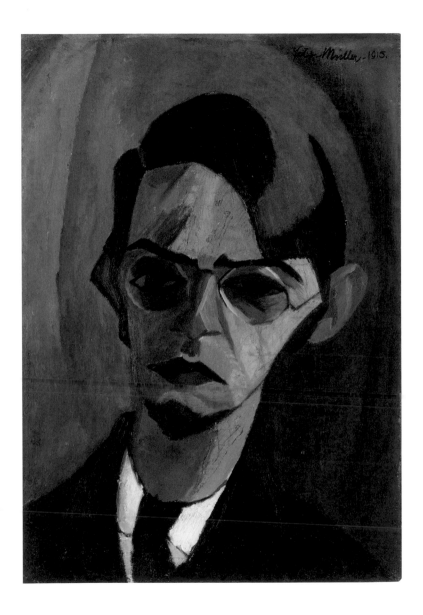

6 *Self-Portrait*, 1915, oil on canvas, 51 × 35.5 cm, private collection

Felixmüller was seen early on to be an ambitious talent, determined to draw attention to himself. To prevent confusion, starting in 1914 he signed himself "Felix-Müller," although he was born Conrad Felix Müller, and then from 1917 "Felixmüller." In 1924 he officially changed his name to "Conrad Felixmüller."

After having already gathered artist friends around him in Dresden, he visited Berlin in 1915 and soon made contacts there as well. In the capital he quickly made the acquaintance of members of avant-garde circles and became friends with Franz Pfemfert, who in the coming years would publish more than 50 of Felixmüller's graphics in *Die Aktion,* the journal he edited. It was at this time that the 18-year-old painted his *Self-Portrait* (6). In it the pastose ductus has been moderated and the face, composed of angular shapes and planes, reveals an image filled with Cubist echoes. The eyes are the picture's power centre, flashing with red and green tones as an indication of innovative artistic power and passion. He was similarly portrayed by his contemporaries as well: full of unrest, with a precocious streak and an unusual presence. This painting is the first important example from a long series of self-portraits made throughout Felixmüller's life and reflecting his lifestyle and his view of himself. These likenesses were never accompanied by meaningful attributes, however, or heightened into an image of the artist in a specific role. He simply pictured himself either alone or accompanied by his wife and children, standing in the midst of life and not always flatteringly, preferably at work in his studio with no pretensions of being a "world-weary genius."[9]

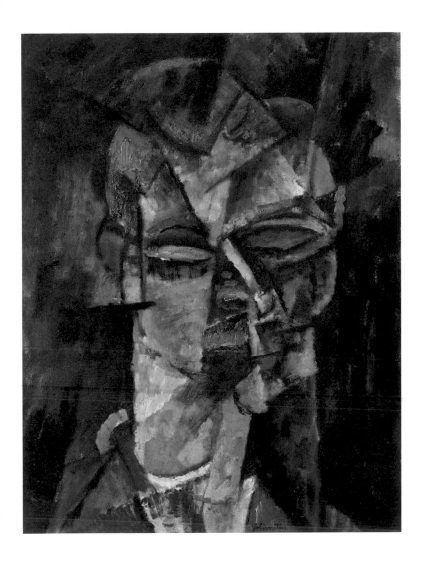

7 *Portrait of Felix Stiemer*, 1918, oil on canvas, 60 × 45 cm
Nationalgalerie, Staatliche Museen zu Berlin

"SYNTHETIC CUBISM. THAT IS ABSOLUTE STRUCTURING OF MATTER AND SPACE."

In early 1914, Emil Richter's Dresden art salon presented a show of recent works by Pablo Picasso. This may have been Felixmüller's first encounter with Cubism, which was further intensified through contacts with artists associated with the Berlin gallery Der Sturm. Engagement with Cubist structural ideas would characterise his woodcuts from now on, also paintings, notably the portrait of his friend Felix Stiemer (7). His features splinter into short lines and seem to press in all directions in exploration of the picture space as though we were looking at him through a cracked mirror. But Felixmüller was not drawn to a theoretical involvement with Cubism. Like other artists, he used it as a way of expressing a growing sense of existential dread in the face of the brutal reality of the war.

The First World War radically changed Felixmüller's view of the world. Driven by his pacifist and increasingly revolutionary convictions, the artist worked tirelessly, "filled with tension like the time." He constantly questioned his "artistic ruminations in the solitude of the atelier,"[10] his struggle with purely aesthetic issues. One famous woodcut bears the telling title *Being Depressed in My Studio*. But at the same time a young woman makes an increasingly frequent appearance in Felixmüller's work – Londa, to whom he dedicated the first in a long series of double portraits in the spring of 1918: "à ma bien-aimée." The woodcut *Betrothal* (8), produced a short time later, shows the couple, reduced to light and dark planes, as balanced shapes turned towards each other, leaning in for a kiss and with hands touching as they make their pledge. In Londa's face there is already a suggestion that her presence in this and other painted and drawn declarations of love led to "emotional gestures"[11] and could thus soften the Cubist severity.

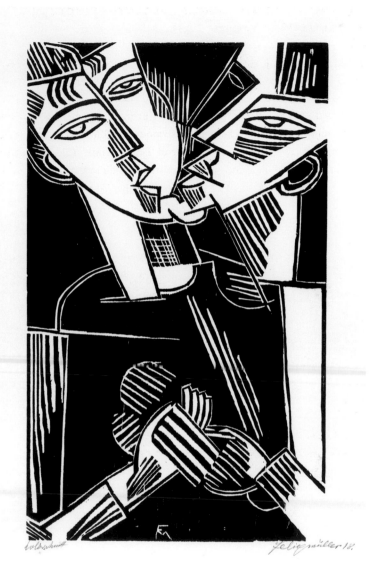

8 *Betrothal*, 1918, woodcut, 50 × 30 cm, private collection

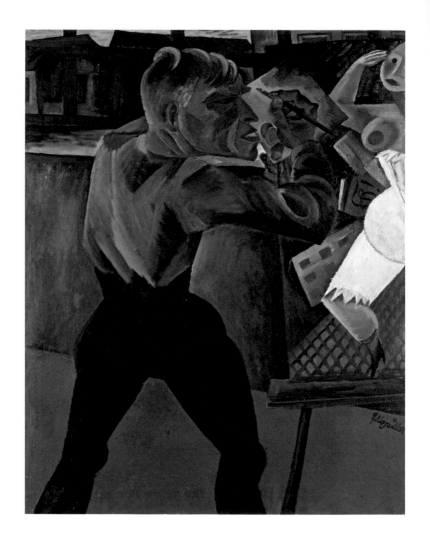

9 *Otto Dix Painting*, 1920, oil on canvas, 120.5 × 95.5 cm
Nationalgalerie, Staatliche Museen zu Berlin

"TO FINALLY SAY GOODBYE TO OLD METHODS AND APPROACHES"

In the autumn of 1918 Felixmüller saw a symbolic link between the revolutionary upheavals after the end of the war and his private good fortune: "Indeed, child and revolution had come into being at the same time. ... The momentous event of the birth of a human being and the simultaneous beginning of the great revolution lifted me up and carried me away ... I was once again a simple man and a proletarian."[12] In order to place his art in the service of the revolution so that he would be able to have an effect on society, Felixmüller tried to create a renewed coalition of avant-garde forces in Dresden after the pattern of Berlin's "Novembergruppe". He and Otto Dix, still virtually unknown at the time, became driving forces in the "Gruppe 1919", the Secession he helped to found. Felixmüller painted Dix in 1920 as a crazed painter attacking one of his pictures (8). Although the two artists respected each other, Felixmüller rejected Dix's motifs and extremes: "Unfortunately the man is completely Dadaist again and 'paints' pornographic pictures of the worst kind; I consider him lost, for this appears to be his nature."[13] The "Gruppe 1919" would be of great importance for the history of art in Dresden after the First World War, but Felixmüller's engagement with it lasted only a year. It had attracted attention with ambitious exhibitions and a number of publications, but Felixmüller's demand for active political commitment had fallen on deaf ears.

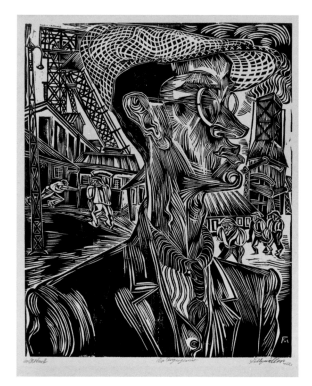

10 *The Mining Engineer*, 1922
woodcut
54.5 × 43.7 cm
P. A. Böckstiegel-
Freundeskreis

"THESE PEOPLE ARE TRAGIC, BEAUTIFUL, GREAT, AND ALTOGETHER HUMBLE"

The artist now turned his full attention to people's living conditions. Through his brother Hellmuth, who was studying mechanical engineering in Chemnitz and whom he later portrayed in *Mining Engineer* (10), Felixmüller gained access to Saxony's coal-mining district. From 1920 he would find his most important motifs in the world of miners. In order to be able to study it intensively, he used the stipend that came with the Saxon State Prize for an extended sojourn in the Ruhr region. The paintings, drawings and prints he made there and later in his studio are of extraordinary art-historical importance; in contrast to many previous depictions of workers, Felixmüller's pictures are without any "genre-like retouchings,"

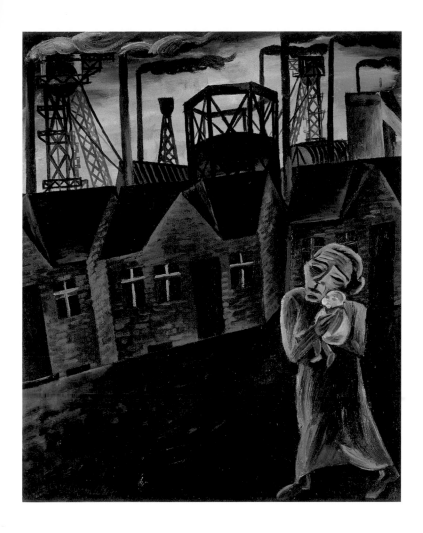

11 *Ruhr District I*, 1920, oil on canvas, 80 × 65 cm, private collection

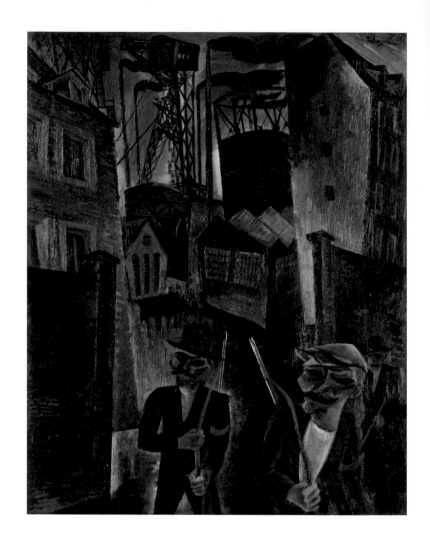

12 *Ruhr District II*, 1920, oil on wood, 95 × 75 cm, LWL-Museum für Kunst und Kultur,
Westfälisches Landesmuseum, Münster

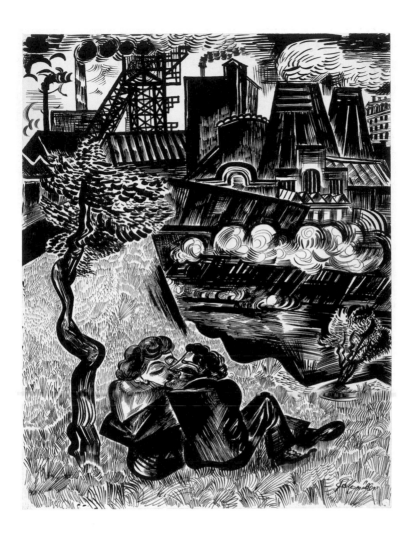

13 *Lovers in Factory Landscape*, 1923, ink on paper, 64.6 × 50.2 cm
Kupferstichkabinett, Staatliche Museen zu Berlin

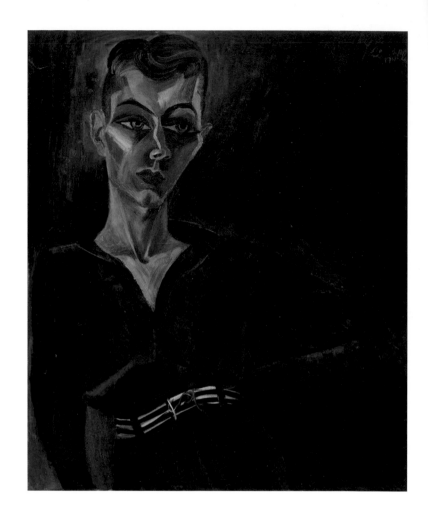

14 *Portrait of Ernst Buchholz*, 1921, oil on canvas, 90×75 cm
George Economou Collection, Athens

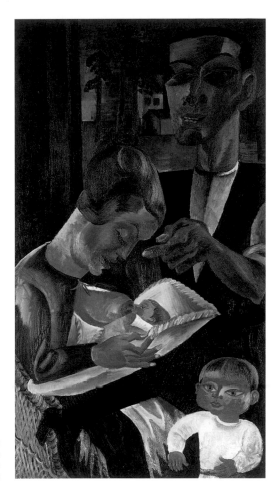

15 *Large Family Portrait: Felixmüllers*, 1921, oil on canvas, 135 × 75 cm Private collection

no "poor-people realism" or "obvious prettifying."[14] Wholly in line with his political convictions, he made them "not in awe of the industrial giants, but in sympathetic admiration for the people associated with them,"[15] the workers and their families. The painting *Ruhr District I* (11) shows a mother with her child in her arms, rushing past a deserted setting of workers' houses and massive coal and steel-industry buildings. In *Ruhr District II* (12), however, three armed workers, probably strike sentries from the

proletarian "Ruhr Militia," appear before the façades of a factory painted in glowing colours and in menacing perspective. A third painting pictures a surreal combination of factory buildings, a smokestack and a huge pipeline which seem to bear no relation to each other. As though the industry had outlived the people who are missing from the picture, the work ends the series with a kind of menacing silence. What Felixmüller saw and experienced made a lasting impression on him and made him reflect on his own situation in life. In these surroundings, which appear so hostile to life and love, he repeatedly drew couples in undisturbed moments of happiness (13). He drew his pen across the paper on these sheets so often that the ink takes on a coal-like sheen and attains the intense black that the artist must have encountered everywhere he looked. Felixmüller developed many of his motifs into prints that attracted considerable attention in exhibitions and reproductions. Critics praised this "most uncompromising, abrasive illustrator of proletarian existence" as one of the "most distinctive forces of the present day."[16]

During these years he also made other representative worker portraits in which the subjects, with their striking features and poses, appear to be either sullen rebels or endearing hoodlums. He devoted himself to them not as members of a "class," but with tremendous respect as individuals, and – most unusually – used their names in his titles. The extreme yet expressive exaggeration of facial features and angular gestures in these portraits is typical of the artist's work during these years. It is also seen in the extraordinary portrait of a 16-year-old Hamburg grammar-school pupil (14), whose self-confident pose Felixmüller turns into a fascinating symbol of growing up, a balance between anxiety and nonchalance, between aggression and androgynous sensuality – a stark contrast to the vital, robust masculinity of the workers.

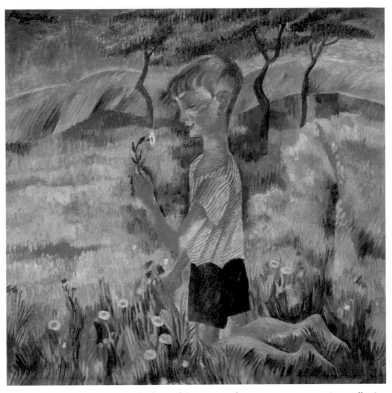

16 *Summer Meadow with Luca*, 1925, oil on canvas, 95 × 95 cm, private collection

Following double page:
17 *Spring Evening – Klotzsche*, 1926, oil on canvas
75 × 90 cm, Frank Brabant Collection

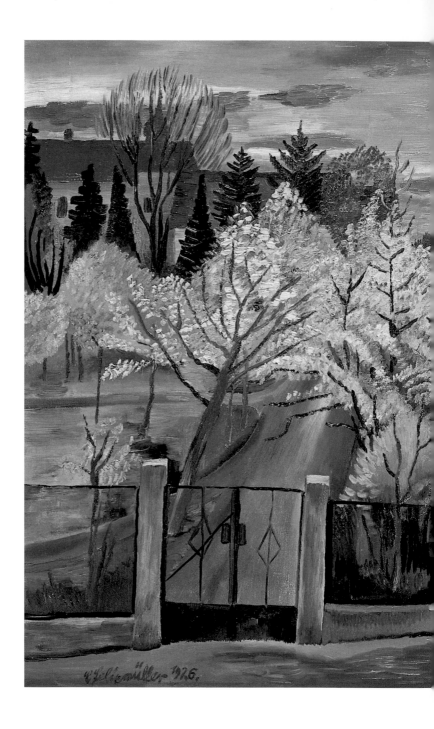

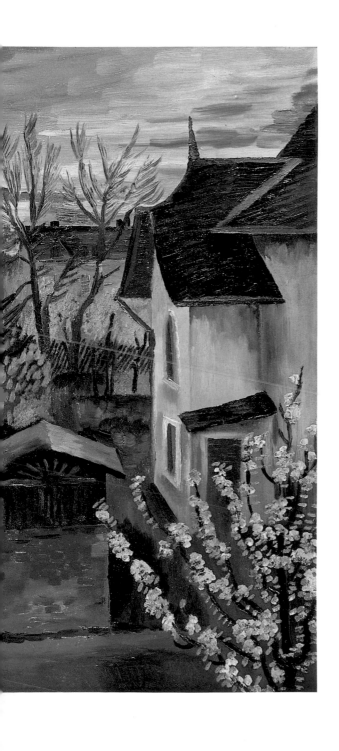

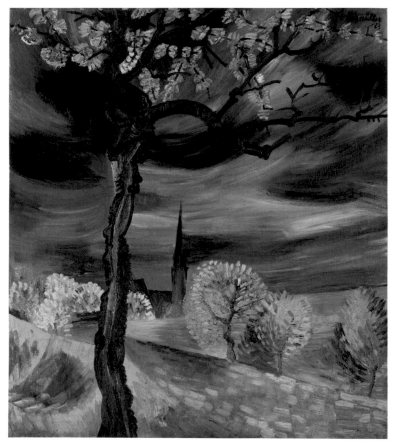

18 *Old Cherry Tree in Blossom*, 1923, oil on canvas, 85 × 75 cm, private collection

"AS A PAINTER YOU SIZE UP YOUR FELLOW MAN IN AN INSTANT"

Felixmüller soon had to recognise that his artistic engagement with the lives of the proletariat was having no obvious effect and that the workers, in turn, had none of the understanding for art he had hoped for. The unity of art and life remained a utopian vision. Felixmüller's disillusionment at the failure of his revolutionary ideas led to an increasing withdrawal into domestic life. In 1918 he had already started a series of paintings with the

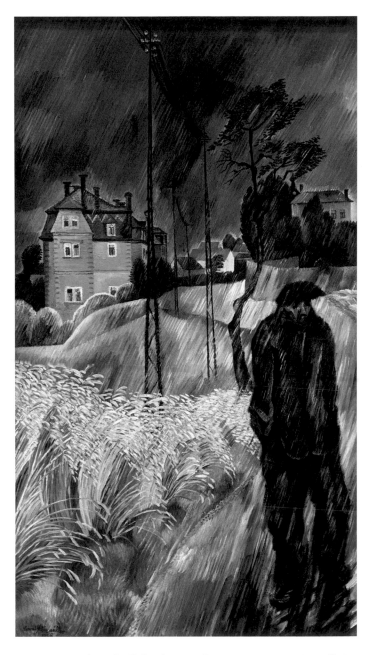

19 *Rain (Unemployed) Klotzsche*, 1926, oil on canvas, 135 × 75 cm, private collection

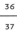

36
37

20 *Klotzsche Children's Home*, 1924
Oil on canvas, 95 × 95 cm, Kunsthalle Bielefeld

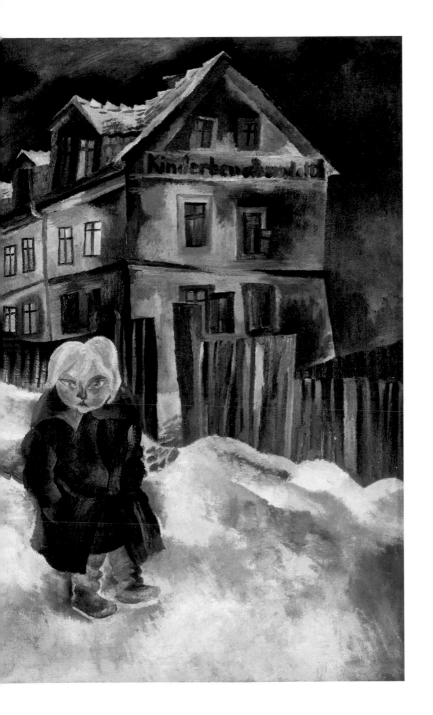

title *Happy Marriage*, showing the importance the artist ascribed to his role as a family man. Londa and their sons Luca and Titus became his principal subjects. All his life Felixmüller would document the growth of his family, later including in-laws and grandchildren in the mix of generations.

His proletarian lifestyle as presented in the *Large Family Portrait* (15) would soon give way to a bourgeois lifestyle that characterises the artist's depictions of himself. Hulda Pankok, the wife of the painter Otto Pankok, recalled "going to Dresden in the early 1920s to visit the supposed revolutionary Felixmüller and being totally surprised to discover the idyll of an intact family".[17] Felixmüller's notion of family definitely had its bourgeois features. His paintings of Londa are by no means celebrations of a modern female type like those of other Weimar Republic artists. Felixmüller was far more concerned to emphasise his wife's classical beauty and elegance. He pictured Londa not only as an adored wife and caring mother, but in equal measure as a desirable muse. Up until her old age she frequently posed for her husband in the nude.

Felixmüller preferred to paint his sons either in harmony with surrounding nature (16) or gazing out of a window and discovering the world around them. This often allowed him to work into his picture features of the local landscape, peaceful Klotzsche at the edge of the Dresden Heath (17), which repeatedly inspired him to create poetic visions of the landscape (18). Even here he remained attentive to the fates of his fellow men (19), but with none of the harshness of his earlier workers' portraits. It is recalled, to be sure, in his painting of a little girl exposed to the icy cold of a winter's day in front of a crooked, garishly shimmering house in which children were "sheltered" (20).

As a result of his increasingly frequent journeys, depictions of landscape now assumed a greater importance in his work. They record his stays in Helgoland (21) and in Bohemia, where he captured the people, landscapes and striking architecture (22). The artist was repeatedly obliged to travel in order to execute portrait commissions – a task that he performed with increasing enthusiasm in these years, and which was also a financial necessity. In the mid-1920s he painted a number of imposing portraits of intellectuals or collectors amongst his acquaintances that as often as not led to further commissions for portraits of their wives or children. Important works of his had already found their way into the collections of

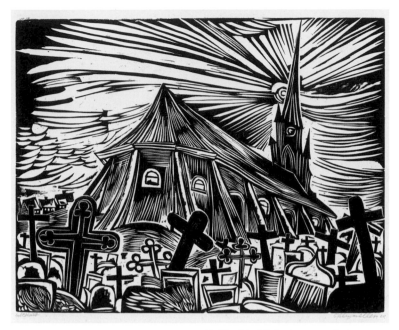

21 *Church in Helgoland*, 1924, woodcut, 41 × 51 cm
P. A. Böckstiegel-Freundeskreis

Heinrich Kirchhoff, August von der Heydt and Ina Bienert, and a short
time later these were joined by the important art lovers Heinrich Stinnes,
Hans Koch, Rudolf Ibach and Ludwig and Rosy Fischer. Once inflation
had subsided, collectors like the writer Carl Sternheim and the gold- and
silversmith Rudolf Feldmann also took an interest in Felixmüller's work
(see pp. 72–74). They followed his career and welcomed his turn toward a
more realistic style of painting, which came from his desire to depict a
harmonious world freed from internal and external struggles and there-
fore considered beautiful, so as to "justify hopes for happiness and

Following double page:
22 *Farmhouse in Bohemia (Volovice near Prachatitz)*, 1924,
watercolour and ink on paper, 33 × 42.5 cm, private collection

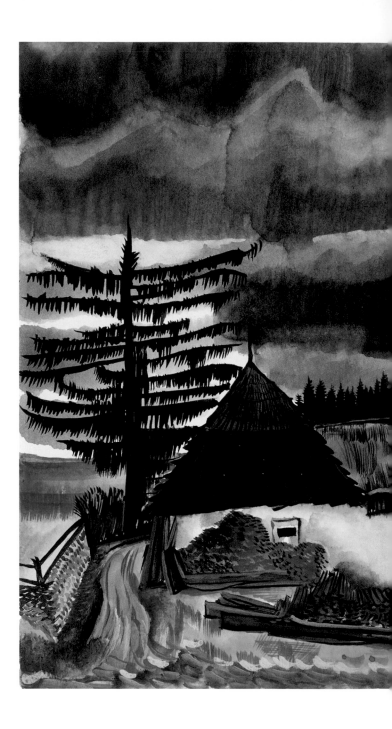

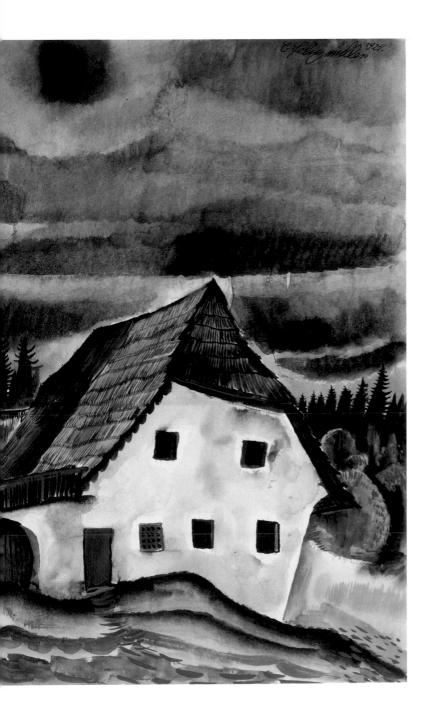

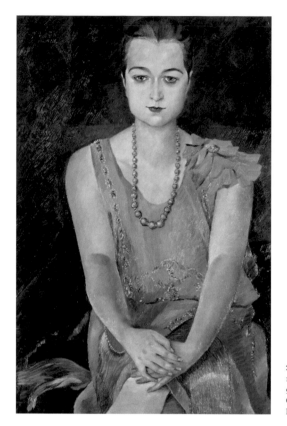

23 Portrait of Jutta Kirchhoff,
1928, oil on canvas
97 × 68 cm, Albertinum,
Galerie Neue Meister,
Dresden

kindness with my work as opposed to the world's evils."[18] Felixmüller softened the expressive realism typical of his portraits. He continued to emphasise his model's eyes, the ridge of the nose, the forehead and the chin, to be sure, and included their delicate hands in the picture for their expressiveness, yet he now also sought the "enamel- and peachlike in complexion, eye, hair, mouth", so as "to paint the beautiful woman beautifully as well" – which included virtuosic rendering of costly jewellery or elegant

24 Peter August Böckstiegel – Arrode – The Painter of his Homeland,
1926, oil on canvas, 135 × 100 cm, private collection

25 *Portrait of Max Liebermann*, 1926, woodcut 50 × 40.2 cm, Museum am Theaterplatz, Chemnitz, Städtische Kunstsamm- lungen

attire (23).[19] To him this was not solely a matter of "development away from experiment," but of "complete command of the artistic medium".[20] This brought him to a kind of "painting in the best sense ... – namely tone next to tone, colour next to colour", rich in colour values and reminiscent of the art of the late nineteenth century.[21]

Art historians have had difficulty identifying this new style. They have proposed the term "elegant realism,"[22] or described it as "objective realism inspired by the New Objectivity" in an "intimate and subtle painting culture" that evolved into an "impressionistically refined naturalism."[23] These were all attempts to position the artist in the vicinity of the New Objectivity so important in Dresden art after 1925, yet in so doing to

26 *Lovers against the Dresden Skyline*, 1928, oil on canvas, 160 × 100 cm Albertinum, Galerie Neue Meister, Dresden

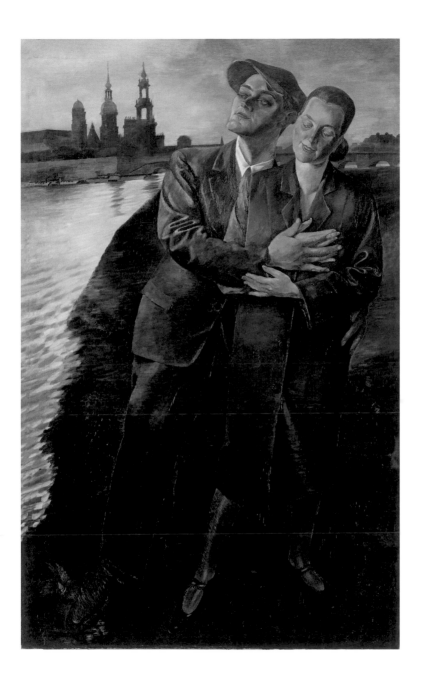

emphasise the independence of his works from the second half of the 1920s. The portrait of Peter August Böckstiegel, dominated by its radiant colours, dates from this time (24). The subject appears to have stepped out in front of his parents' house impatiently, brush in hand, his trousers barely closed, hoping to find inspiration there in tune with surrounding nature. Such portraits are by no means objective, cool, "veristic" depictions preserving a distance from the subject. By contrast, the pencil drawings from this time are altogether in the mode of the New Objectivity. With great mastery Felixmüller refined his woodcuts down to the smallest details. Typical examples are *Self-Portrait as Draughtsman* and his portrait of Max Liebermann (25), one of his most famous prints. The latter and similar portraits of Lovis Corinth and Christian Rohlfs seem like testimonials to important representatives of an older artist generation, and not without reason. Unlike a decade previously, Felixmüller now felt scarcely any ties to his contemporaries, and certainly not to a younger, aspiring generation. He kept his distance from such newly formed artists' associations as "ASSO" or "Dresden Secession 1932." This, along with his own artistic evolution, led to a further distancing from former associates – and also brought him considerable criticism. He was frequently chided for his concentration on domestic motifs, to which the artist countered that a person must "be of a very unhappy disposition … if he cannot draw happiness from himself and those around him".[24] Nevertheless, Felixmüller was hurt when it was said of him that he had not only "raised himself to faithful drawing and competent painting,"[25] but also turned "away from the blatant, even rude … to the cloying. … Most of his more recent works, in search of ethics and beauty instead of the demonic, end up being kitsch."[26] Criticism from conservative, nationalistic quarters also began at this time, vilifying the artist as a former revolutionary: "Felixmüller's reputation as an artist should be ground between the millstones of political and artistic reproaches, between 'communism' and 'kitsch'."[27] Yet in spite of such attacks and financial hardship he remained convinced that he was on the right course; he could rely on his loyal admirers and found reassurance, for example, in the public success of his monumental painting *Lovers against the Dresden Skyline* (26). It pictures the artist, now 31 years old, with his wife against the silhouette of a Baroque Dresden, content in the here and now, with a confident, almost visionary gaze directed into the future. Felixmüller had long since begun to judge his early work harshly; he

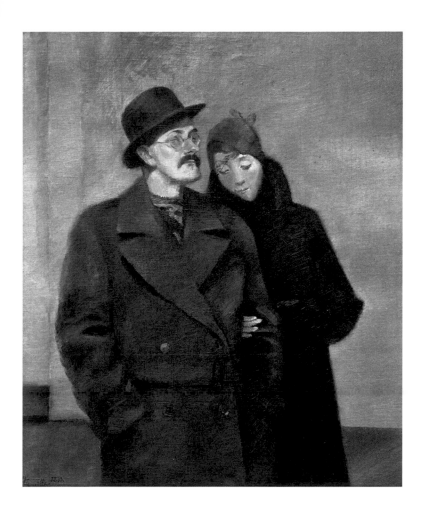

27 *Self-Portrait with Londa*, 1933, oil on canvas, 67 × 58 cm, private collection

repeatedly invited his collectors to return earlier pictures in exchange for recently painted ones, but mostly without success. He painted new pictures on the backs of canvases still in his possession – as if he could make the "sins of his youth" disappear. He destroyed a large number of his prints with his own hands, even though they were especially prized by collectors: "Time will certainly be the judge – we can leave it up to her. As for me, I will judge myself – entire editions of prints and dozens of paintings have ended up in the stove."[28]

"DO YOU WANT ART OR KOWTOWS"

Felixmüller's œuvre does not divide into obvious phases or abrupt changes in style. One senses his desire for continuity, maintaining what he had achieved, even through such dramatic turning points in his life as the beginning of the Nazi dictatorship and his move to Berlin. Aside from the appearance of urban motifs these left few traces in his work. Even though there was nothing obviously objectionable in his painting from these years, either in form or in content, it was repeatedly discredited and he was accused of fomenting class strife. In Dresden, especially, he was subjected to intense ridicule by the National Socialists (see pp. 74–76). Because he had few chances to exhibit his work, the years of the Nazi dictatorship were a time of extreme financial distress for him, only worsened by the feelings of isolation he experienced in Berlin. A double portrait (27) painted at the beginning of 1933 seems like a premonition of the difficult situation the family would soon face.[29]

In the following years he produced mainly portraits of a small circle of friends, domestic scenes, and time and time again paintings of Londa. The latter were often staged as atelier pictures in which the artist pictures himself at work – a retreat into a sheltering space and at the same time a self-confident commitment to art. Landscapes also became increasingly common in these years. Many of his paintings were executed as commissions: "I was soon earning our daily bread at this or that estate, palace or castle – surrounded by ancient art, ancestral portraits, in magical landscapes and without public complaints."[30] Hanns-Conon von der Gabelentz became increasingly helpful, setting up contacts as a devoted collector and friend. Thanks to the artist's love of portrait painting, the family was just

able to manage during this distressful time, but during the Second World War there was almost no possibility of securing even this modest income. In Berlin Felixmüller abandoned printmaking altogether. His painting had returned completely to a refined, almost Impressionistic style, distinguished by harmoniously balanced colours enlivened by subtle contrasts. His renderings of nature from this time continued to be largely evocations of life's quiet joys: fruit trees in lavish blossom, the special light and air of autumn, or – his favourite – snow-covered winter landscapes (28). Given the tremendous challenges he was facing at the time, they were surprisingly "well-tempered paintings"[31] that would later be described, somewhat too harshly, as "mind-numbing".[32] After his move to Damsdorf in 1941, having been forced out of Berlin by his fear of the increasing bombing raids and attracted by better living conditions in the country, he naturally turned to rural motifs: depictions of local farmers and blacksmiths, weavers and spinners – replacements for the formal portraits he could no longer paint. In the last years of the war Felixmüller moved to Tautenhain in Saxony. The paintings he created there have almost no hint of wartime concerns, which can be seen only in the portraits of his sons in uniform, for they had both been called up at the start of the war. It was only after 1945 that the bombed-out inner cities of Berlin and Leipzig make an appearance; in the previous years any return to an engaged, not to mention critical art was unthinkable.

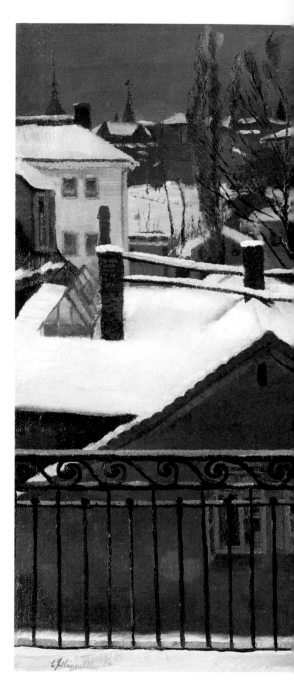

28 *Melting Snow (View from the Veranda)*, 1934
Oil on canvas, 58 × 64 cm
Private collection

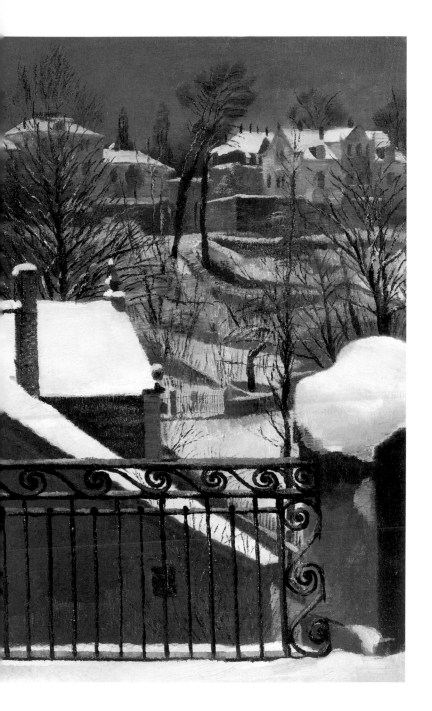

29 *Machinist in the Lignite Works at Neukirchen-Wyhra (Junghans)*, 1951
Oil on canvas, 110 × 90 cm, Lindenau-Museum, Altenburg

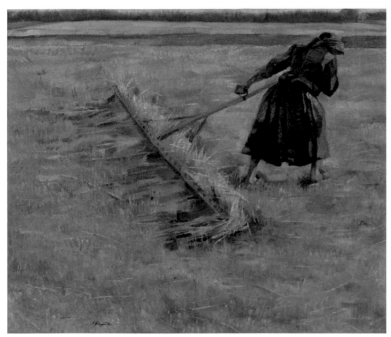

30 *Hunger Rake, Mother Riefling*, 1941, oil on pressboard
58.5 × 67.3 cm, Lindenau-Museum, Altenburg

"I AM POSSIBLY SITTING BETWEEN TWO STOOLS AT THIS PLAY, THIS TRAGEDY"

Once the war ended the artist's life was first filled with practical matters, securing what he needed to live on. Much of what he saw around him would find its way into woodcuts, which he now carved in great numbers: people trading things across the inner-German border, thefts of coal, potato stubble. He had always loved making woodcuts, and in them he chronicled the postwar years with uncommon dedication, both critically and with empathy (see pp. 76–77). In his painting he still sought continuity and a connection to his work before 1933, in the hope he shared with many other artists of being able to take part in the artistic life of all Germany, despite its division into two hostile halves. Needless to say, in exhibitions

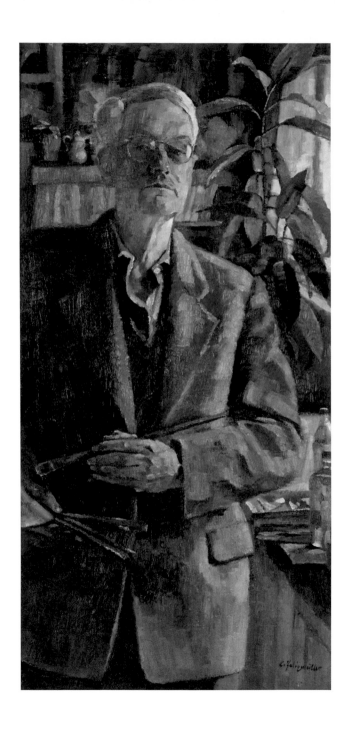

in the 1940s and 50s on both sides of the border his work was variously judged and interpreted.[33] In East Germany it met with only limited approval, for it failed to conform to the guidelines set by the authorities. Felixmüller necessarily got caught up in the debate over the establishment of "Socialist Realism" as the official state art style. Thanks to his professorship in Halle an der Saale he was financially secure, but he was denied the possibility of showing his work free of official rebuke. Even his depictions of workers (29), like many of his late works recalling motifs from the early 1920s, were subjected to public criticism. His portrait of a machinist in the coal works focused on the man's personality, deliberately seeing him as an individual as opposed to a mere cog in the machine. Felixmüller had no interest in portraying the man as a mere patriotic worker, as was officially demanded.

It is difficult to determine just when Felixmüller's "late work" begins. His painting from the 1950s to the 1970s is characterised by an adherence to a realistic style, in later years with a broad, more relaxed ductus and spots of radiant colour (30). In these politically tumultuous years he no longer expressed any opinions about political issues or artistic developments. He definitely declined to align himself with the artistic avant-gardes of the period. This was unusual given that his horizons had once again expanded; on retiring from his professorship in 1962 he moved initially to East Berlin, capital of the German Democratic Republic, before settling in West Berlin in 1967. The latter move finally allowed him to take up old contacts and enjoy a closer connection with his family. In this period his work was included in numerous exhibitions, occasioning travel all over Europe. He was now most inspired by the unrest of his grandchildren's generation, so that he finally found himself picturing not only urban Berlin but also student life in a turbulent time. Even though he repeatedly made an appearance himself, he ultimately remained only an observer on the sidelines – and this at a time when he was being rediscovered, especially his politically engaged work from the 1920s (31). Conrad Felixmüller – later categorised by art historians as a representative of the so-called "second generation" of Expressionism – was now seen as an important proponent

of Modernism in Germany, an artist who had remained true to his artistic credo with self-assurance and unwavering conviction. He had presented that credo in his programmatic essay *On Art* ("Über Kunst") from 1925: "Mankind. Art should express it. That is what I try to do."[34]

DAVID RIEDEL *studied art history and Danish philology in Münster and Paris. After working in the Staatliche Kunsthalle Baden-Baden and the Kunsthalle Bielefeld, he became the artistic director of the Museum Peter August Böckstiegel in Werther bei Bielefeld in 2012. He curated the exhibition* Family Ties – Conrad Felixmüller. In Arrode *there in 2021. He is the author of the catalogue raisonné of the paintings of Peter August Böckstiegel and other writings on modernist art in Westphalia.*

1 Letter from Conrad Felixmüller to Carl Bantzer from 30 December 1931, quoted from Susanne Thesing, "Abkehr vom Expressionismus – Zum Spätwerk Conrad Felixmüllers", in: *Conrad Felixmüller. Werke und Dokumente*, published by the Archiv für Bildende Kunst am Germanischen Nationalmuseum Nürnberg, Klagenfurt 1981, p. 17.

2 Stephanie Barron, "Der Ruf nach einer neuen Gesellschaft", in: *Expressionismus – Die zweite Generation. 1915–1925*, exh. cat. Kunstmuseum Düsseldorf and Staatliche Galerie Moritzburg Halle, Munich 1989, p. 39.

3 See Heinz Spielmann (ed.), *Conrad Felixmüller. Monographie und Werkverzeichnis der Gemälde*, Cologne 1996, and Gerhart Söhn (ed.), *Conrad Felixmüller. Das graphische Werk 1912–1977*, Düsseldorf 1975.

4 Peter W. Guenther, "Bemerkungen zum 'Jungen Felixmüller'", in: Felixmüller 1981 (see note 1), p. 11.

5 Conrad Felixmüller, "Über Kunst" (1925), in: Gerhart Söhn (ed.), *Conrad Felixmüller: von ihm – über ihn*, Düsseldorf 1977, p. 54.

6 Conrad Felixmüller, quoted from G. H. Herzog (ed.), *Felixmüller. Legenden 1912–1976*, Tübingen 1988, p. 22.

7 Conrad Felixmüller, "Peter August Böckstiegel (Ein Nachruf)", in: Söhn 1977 (see note 5), p. 135.

8 Conrad Felixmüller, in: Herzog 1977 (see note 6), p. 24.

9 Conrad Felixmüller, "Malerglück und Leben" (1929), in: Söhn 1977 (see note 5), p. 101.

10 Conrad Felixmüller, in: Herzog 1977 (see note 6), p. 30 and 28.

11 Ibid., p. 38.

12 Conrad Felixmüller, "Der Prolet (Pönnecke)", quoted from Felixmüller 1981 (see note 1), p. 80.

13 Conrad Felixmüller, in: Herzog 1977 (see note 6), p. 46.

14 Willi Wolfradt, "Berliner Ausstellungen", in: *Der Cicerone* 15 (1923), pp. 985f.

15 Letter from Conrad Felixmüller to Heinrich Kirchhoff from 27 July 1920, quoted from Felixmüller 1981 (see note 1), pp. 90f.

16 Quoted from Wolfradt 1923 (see note 14).

17 Quoted from Gerhart Söhn, "Engagierte Grafik eines Humanisten", in: Felixmüller 1981 (see note 1), p. 25.

18 Conrad Felixmüller, "Trotz aller Zynismen" (1925), in: Söhn 1977 (see note 5), p. 61.

19 Letter from Conrad Felixmüller to Dr. Hermann Luppe from 13 March 1932, quoted from Felixmüller 1981 (see note 1), p. 127.

20 Letter from Conrad Felixmüller to Rudolf Feldmann from 25 November 1925, quoted from *Conrad Felixmüller an Rudolf Feldmann – Briefe an einen Kunstfreund (1924–1958)*, ed. David Riedel, exh. cat. Museum Peter August Böckstiegel, Werther 2021, p. 145.

21 Conrad Felixmüller, "Einführung in sein Gemäldekollektiv", quoted from Felixmüller 1981 (see note 1), p. 127.

22 Christian Rathke, "Das Jahr 1924", in: idem (ed.), *Conrad Felixmüller*, exh. cat. Schloss Gottorf and elsewhere, Neumünster 1990, p. 34.

23 Peter Barth, *Conrad Felixmüller – Die Dresden Jahre 1913–1933*, exh. cat. Galerie Remmert & Barth, Düsseldorf 1987, p. 97.

24 Felixmüller 1929 (see note 9), p. 101.

25 Willi Wolfradt, "Berliner Ausstellungen", in: *Der Cicerone* 21 (1929), p. 201.

26 Franz Roh, "Kunst der Gegenwart München 1930", in: *Der Cicerone* 22 (1930), p. 391.

27 See Barth 1987 (see note 23), p. 119.

28 Letter from Conrad Felixmüller to Carl Bantzer from 30 December 1931, quoted from Felixmüller 1981 (see note 1), p. 125.

29 A first detailed discussion of this period can be found in Thomas Bauer-Friedrich, " 'gestempelt trotz grosser Entwicklung.' Conrad Felixmüller in den Jahren zwischen 1933 and 1945", in: *Conrad Felixmüller. Zwischen Kunst und Politik*, ed. Ingrid Mössinger and Thomas Bauer-Friedrich, exh. cat. Kunstsammlungen Chemnitz and elsewhere 2012–2014, Chemnitz 2013, pp. 114–130.

30 Conrad Felixmüller, quoted from Herzog 1977 (see note 6), p. 98.

31 Hanns-Conon von der Gabelentz, quoted from Dieter Gleisberg, *Conrad Felixmüller – Leben und Werk*, Dresden 1982, p. 58.

32 Klaus Türk, "Anmerkungen zum Thema der Arbeit im Werk Conrad Felixmüllers", in: *Conrad Felixmüller – Strudelnd im Strom der Zeit*, published by the Verein August Macke Haus e.V., exh. cat. August Macke Haus Bonn, Bonn 2001, p. 87.

33 See Thomas Bauer-Friedrich, " 'Man kann nicht malen wie der Ochse brüllt.' Betrachtungen zu Conrad Felixmüllers Schaffen zwischen 1945 and 1967", in: exh. cat. Chemnitz and elsewhere 2012–2014 (see note 29), pp. 166–179.

34 Felixmüller 1925 (see note 5), p. 55.

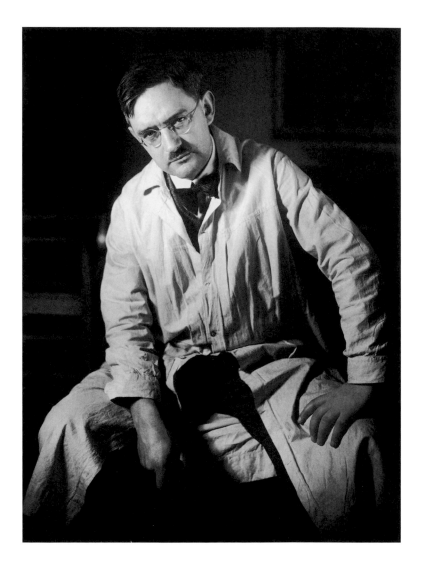

32 Conrad Felixmüller in his studio, 1933

BIOGRAPHY

Conrad Felixmüller

1897–1977

1897–1911 Conrad Felixmüller is born as Conrad Felix Müller in Dresden on 21 May 1897. He is the son of Ernst Emil Müller (1870–1943), who works as a blacksmith in a piano factory, and Maria Karolina Müller, née Morche (1873–1918), who operates a creamery in the Johannstadt district. He has two siblings, an older sister Hanna (1894–1988) and later a younger brother Hellmuth (1900–1990). Even before he finishes primary school his father makes it possible for him to take piano and violin lessons, and subsequently drawing instruction, at the School of Arts and Crafts.

1912–1914 Thanks to a private stipend from the merchant Johannes Mühlberg, Felixmüller, although barely 15 years of age, is able to attend the Ferdinand Dorsch painting school. In December 1912, though not yet ready for full participation, he is accepted into Carl Bantzer's painting class at Dresden's Art Academy. On a study trip to Schwalm in North Hesse with his teacher in the summer of 1913 he produces his first oil paintings, having shortly before executed the print cycle on Arnold Schönberg's *Pierrot Lunaire* after poems by Albert Girard. In the fall of 1913 Felixmüller becomes friends with the artist Peter August Böckstiegel and is impressed by the latter's expressive paintings. His sister Hanna and Böckstiegel will marry in 1919. Felixmüller decides to leave the Academy after only three semesters. In May 1914 his prints are exhibited at I. B. Neumann's Graphisches Kabinett in Berlin.

1915–1918 At 18 Felixmüller is already a freelance artist. The Dresden art dealer Emil Richter concludes a "purchase contract" with him, initially for three years, at a monthly remuneration of 100 marks. For his first solo exhibition a catalogue of his prints is published as well as the "Commitment" ("Bekenntnis") – Felixmüller's first written statement about his art. A trip to Berlin in the summer of 1915 brings him in contact with the gallerist Herwarth Walden, the artists Ludwig Meidner and Raoul Hausmann, and the writers Walter Rheiner and Theodor Däubler. He enjoys their progressively-minded society, united in its rejection of the war, and commits himself to sending work to the journal *Der Sturm* and for many years to *Die Aktion*, with whose editor, Franz Pfemfert, he also becomes friends. Back in Dresden, Felixmüller turns his atelier into a meeting place for artists and writers. "Expressionist soirées," discussion evenings and readings lead to the founding of the "Expressionist Working Community Dresden"

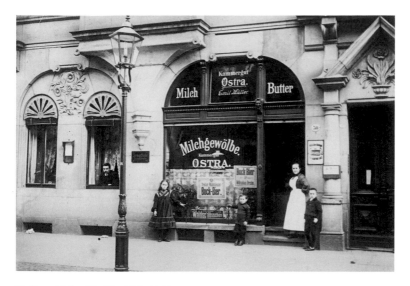

33 Conrad Felixmüller (far right) with his
parents, his brother Hellmuth and his sister
Hanna in front of his mother's creamery at
Stephanienstrasse 50 in Dresden, c. 1907

34 Conrad Felixmüller working on a portrait of
the painter Annemarie Heise in his atelier, 1913

35 Londa Baroness von Berg and
Conrad Felixmüller, 1917

in the autumn of 1917 as well as the journal *Menschen*, published through the book dealer Felix Stiemer. An active, pacifist cell of the avant-garde is formed in Dresden in the middle of the war involving both Stiemer and Walter Rheiner. Felixmüller exhibits at the Galerie Arnold in 1917 as part of the "Group 1917", and is able to sell a number of works. In December, shortly after he becomes acquainted with Londa Baroness von Berg (1896–1979), he is conscripted as an orderly in a military hospital in Arnsdorf, having repeatedly refused to serve in the army. In June 1918 he and Londa marry, and the young couple spend the summer in Wiesbaden. There the collector Heinrich Kirchoff secures a three-year right of first refusal agreement for the artist's paintings with a monthly advance of 250 marks. In October the couple's son Luca is born, named after the Italian Renaissance master Luca Signorelli. Felixmüller expands his network: in Düsseldorf he makes contact with the art dealer Ludwig Schames. On returning from Wiesbaden the young family settles in Klotzsche, near Dresden.

1919–1925 Filled with hope of social changes following the end of the war and the revolution, the artist becomes a member of the German Communist Party, and in January 1919 initiates and becomes a founding member of the Dresden Secession "Group 1919." In April 1919 the group is able to exhibit works by its members, among them Böckstiegel, Otto Dix and Lasar Segall, at Emil Richter's, and additional shows follow in Berlin and Dresden. Felixmüller urges the group to engage in unified political action, but without success, and in January 1920 he withdraws from it. In the same year he is awarded the Rome Prize, the state prize for painting, but instead of using its stipend for the expected stay in Rome, he undertakes a study trip to the Ruhr region. There, in the summer of 1920, he visits blast furnaces and coal mines, and observes the everyday lives of the labourers. The pictures in which he recorded his impressions are among Felixmüller's central works, and are exhibited at Berlin's Nationalgalerie as early as 1923. Numerous exhibitions in German museums and galleries make the artist well known, and his reputation is further enhanced by publications and articles in art journals by Carl Sternheim, among others, who becomes a close friend and collector. At this time Felixmüller not only works at making further contacts but is increasingly awarded commissions for portraits, which both for financial reasons and in view of his image of himself as an artist, become an increasingly important part of his oeuvre.

36 Conrad Felixmüller and his father, c. 1920

37 Conrad Felixmüller with his son Luca on his lap, his brother Hellmuth (right),
his sister Hanna and Peter August Böckstiegel on the day of their marriage, 5 July 1919

His revolutionary hopes having been quashed, in 1924 he withdraws from the Communist Party and searches for a new direction in his work, both in subject matter and in style. Domestic motifs assume increasing importance. In December 1920 Felixmüller becomes a father again with the birth of his son Titus, named after the son of Rembrandt.

1926–1933 In the years between 1924 and 1927, Felixmüller's graphic work culminates in large woodcut portraits before he once again concentrates more on his painting. He is represented in a number of exhibitions in Dresden, Berlin and other cities, and receives official recognition: in 1928 the Sächsischer Kunstverein awards Felixmüller its Grand Prize for his painting *Lovers against the Dresden Skyline* (26); in 1931 he receives the Grand Prize from the State of Saxony and a scholarship from the Albrecht-Dürer-Stiftung in Nuremberg; and in 1932 he wins the art prize of the City of Dresden. New collectors seek him out; especially important are Hanns-Conon von der Gabelentz and Maria ("Mo") von Haugk, who become close friends. But there are still rejections. The vacant professoral chair at the Academy following the death of Otto Gussmann is filled by Otto Dix. Felixmüller later hopes to succeed Richard Dreher as director of a painting class there, but Richard Müller, the Academy's new director installed by the National Socialists in 1933, blocks his appointment.

1933–1945 In September 1933, shortly after the National Socialists seized power, three of Felixmüller's paintings and a number of his prints are featured in a show of "degenerate art" mounted in Dresden. In 1934 he joins the Reich Culture Chamber and moves with his family to Berlin-Charlottenburg, hoping to be able to work there in peace. He is able to show his work in smaller public exhibitions, and in 1937 he is even honoured at the spring exhibition of the Association of Berlin Artists. A short time later, however, a defamatory article in the journal *Der SA-Mann* once again vilifying the artist's past leads to his dismissal from the Chamber. That summer, four of his paintings and three of his prints are included in the Munich exhibition *Degenerate Art*. Before this, at least 151 works of his had been among those confiscated from German museum collections. During these years Felixmüller travels to London and Norway. There, and especially in Germany, he is still able to execute a number of commissions for portraits and landscapes – mainly arranged through Hanns-Conon von

38 Conrad Felixmüller
(right) and Otto Dix (left)
1921

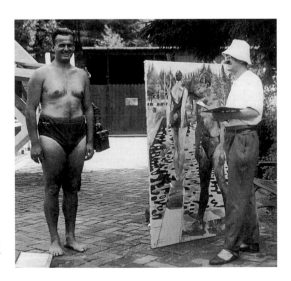

39 At the Klotzsche
outdoor pool working on
the painting *Middle
German Shot Put Master
Seraidaris*, 1931

der Gabelentz – that assure him a modest income. In 1941, increasing bombing raids on the capital force Felixmüller to move to Damsdorf in the Brandenburg Marches. In one raid his studio-cum-apartment in Berlin and a number of his works are destroyed. The family soon finds a new home in Tautenhain, near Leipzig, in a barn converted by the artist himself; it will serve as his workplace for the next 17 years. In the very last months of the war Felixmüller is conscripted into the Volkssturm as a rifleman, and from April to July 1945 is held as a prisoner of war by the Russians.

1946–1966 Shortly after war's end, Hanns-Conon von der Gabelentz hosts a first Felixmüller exhibition at his family seat, Castle Poschwitz near Altenburg, with works from his own collection. In 1946 the artist is included in the first *General German Art Exhibition* in Dresden and again attempts to participate in the city's cultural life. Despite the objections of certain students and local artists, in May 1949 he is awarded a teaching post in painting and drawing at Martin Luther University in Halle. With a one-man show at Halle's Moritzburg, Felixmüller is drawn into the emerging debate over realism and formalism in art, as a result of which his pictures are repeatedly refused at other exhibitions. In addition to his painting, Felixmüller again devotes himself to printmaking. He produces illustrations and stage designs as well as the woodcut series *The Painter's Year*, from 1947, and *I Saw and Carved in Wood*, from between 1947 and 1951. His son, now living in Hamburg, publishes this autobiographical cycle privately, since the GDR officially refuses to grant a publication permit. In 1951/52 Felixmüller produces six large-format paintings for the galleries of the Jakobuskirche in Tautenhain. In 1957, on his 60th birthday, the Kunstmuseum Düsseldorf and the Lindenau-Museum in Altenburg mount first retrospectives, and in 1965 a comprehensive show at the Galerie Nierendorf leads to his rediscovery in the Federal Republic. By this time he is living in Berlin Köpenick, to which he moved in 1962, the year he retired from his professorship in Halle.

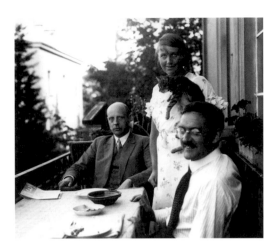

40 Conrad and Londa Felixmüller with Hanns-Conon von der Gabelentz, 1933

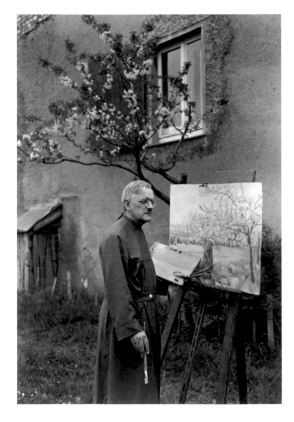

41 Conrad Felixmüller working on the painting *Garden in Spring (Woman Digging)* in Tautenhain 1949

1967–1977 Felixmüller spends the last decade of his life in Berlin-Zehlendorf, having been able to leave East Germany at the age of 70. These years are filled with travels, as he receives increasing recognition for his work with exhibitions in Rome, Bologna, Regensburg and Paris. His works are exhibited in both East and West Germany; for his 75th birthday both the Lindenau Museum and West Berlin's National Gallery host retrospectives, and three years later East Berlin's National Gallery does as well. In 1974 he is awarded a gold medal at the Fourth International Graphics Biennale in Florence. In 1975 Gerhart Söhn publishes the catalogue raisonné of his graphic work.

Conrad Felixmüller dies on 24 March 1977, and is buried in the cemetery at Berlin-Zehlendorf. Londa Felixmüller will die in 1979, and his sons Luca (1918–2006) and Titus (1920–2000) will administer the artist's extensive estate. Titus will support any number of exhibitions and publications on his father's work, including the catalogue raisonné of his paintings published by Heinz Spielmann in 1996.

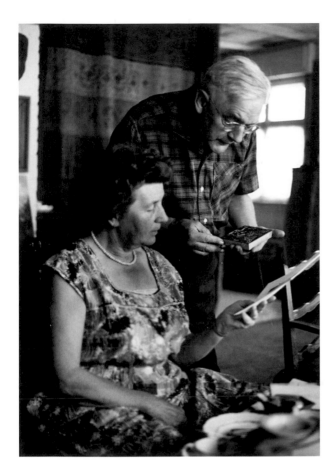

42 Conrad and Londa
Felixmüller examining
a woodcut, c. 1975

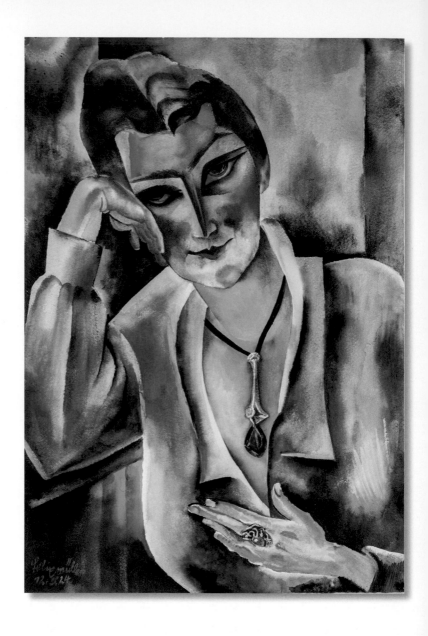

Londa (The Pretty Jewel), 1924, watercolour on paper, 56.5 × 38 cm
Bunte Collection, formerly Rudolf Feldmann Collection

ARCHIVE

Findings, letters, documents
1924–1953

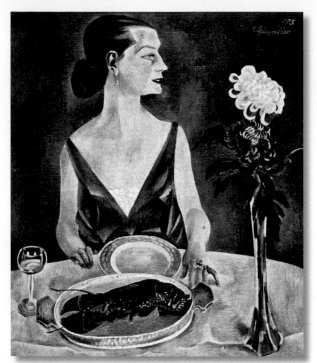

I a

I

The support of his collectors was of the greatest importance to Conrad Felixmüller throughout his life.

"You didn't always receive cash – even produce from friends of art was welcome. … For the jewel of the pretty woman the highly regarded silversmith Feldmann traded some of his wonderful works of art that would in turn adorn many of my pictures."

The gold- and silversmith Rudolf Feldmann (1878–1958), who worked in Bielefeld, met Conrad Felixmüller in 1924. Each of them admired the other's works. Feldmann became an enthusiastic Felixmüller collector, and Felixmüller wrote Feldmann that he stood before his works "as before comets." A silver

I a *Londa – Beauty,* 1925, oil on canvas, 105 × 90 cm, lost
Formerly Städtische Galerie Dresden

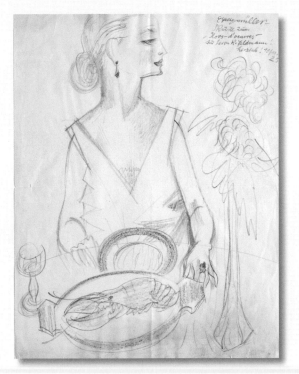

1b

pendant set with smoky quartz was the first gem Felixmüller was able to purchase. Immediately after receiving the piece he painted a portrait of his wife wearing it, visibly proud, and sent the resulting watercolour to Bielefeld as payment. From then on Felixmüller would not only rave about Feldmann to friends and art dealers, but was able to acquire other pieces of his jewellery for his wife, either by purchase or exchange.

Among them were a ring and elegant earrings that appear in the painting Londa – Beauty *from November 1925. In a letter to Feldmann in which he enclosed a preliminary drawing of the work, Felixmüller gave it the suggestive title* Hors-d'œuvres. *The painting not only appears to celebrate beauty; in the*

1b Sketch for the painting *Hors-d'œuvres* from a letter to
Rudolf Feldmann from 10 November 1925, private collection

depiction of his elegantly dressed wife with a lobster on the table in front of her and a chrysanthemum in a slender vase, it also aims to appeal to all the senses. Felixmüller must have attached great importance to this work, for in the summer of 1926 he showed it at Dresden's International Art Exhibition. *The artist Otto Griebel noted: "There was a painting by Conrad Felixmüller ... that he called 'Beauty,' and that attested to a remarkable change in this artist. In this painting in somewhat cloying colours you saw an elegant lady. ... What the picture expressed could be summed up with a line from Brecht's* Three-penny Opera: *'Only the rich folks have it easy.'"*

The painting was immediately purchased for the collection of Dresden's Städtische Galerie, and with the money the family was able to spend several weeks in Le Lavandou on the French Riviera. There Felixmüller painted bright watercolours that revel in the late-summer atmosphere of the place. But he could not get excited about the region. After returning home he wrote: "It's a mistake to find the South more beautiful, more interesting, somehow better than the North. ... How I love painting my Klotzsche and my native Saxony. Even though the weather is more changeable (more complicated to paint) and the red wine is more expensive. ... Travel to the South is booming – but I doubt that much will come of it for art."

On the return journey in October 1926, Felixmüller again visted Rudolf Feldmann, and not only painted a portrait of his brother-in-law Böckstiegel (24) but also the long-planned official portrait of his collector, which Feldmann proudly hung in his showroom. Meanwhile Londa – Beauty *would suffer a very different fate: in September 1933 it was defamed as being "degenerate" in an exhibition in Dresden's Rathaus, and is now considered lost.*

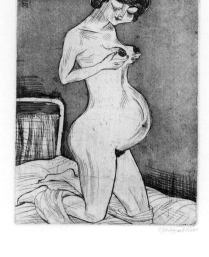

2

During the Nazi dictatorship at least 151 of the artist's works were confiscated from German museum collections as being "degenerate." Felixmüller's art was publicly discredited in Dresden early on. Rejection of his earlier Expressionist and politically engaged works was mixed with criticism of his Communist Party affiliation and his Secessionist activities after the First World War.

In the late summer of 1933 roughly 40 works by Felixmüller from Dresden collections were displayed in the city's Town Hall under the title Degenerate Art. *Richard Müller, the new director of the Art Academy, ridiculed them as "reflections of the decline in art." They were pieces that had been purchased since the early 1920s, and most of them were then included in a show that travelled*

2 *Pregnant Woman*, c. 1920, etching, 25.5 × 20.5 cm
Private collection, Bochum

to twelve other cities. They also served as part of the core of the exhibition, also titled "Degenerate Art", that opened in Munich in the summer of 1937, sealing the fate of modern art in Germany once and for all. In it Felixmüller was re-presented with four paintings and three prints, and the show was seen in a number of German cities up until 1941. In the previous years, Felixmüller had made use of the freedom of movement still afforded him and had been able to show his work in public, but that ended in 1937, which meant that his financial situation became dire. This darkest period in his life has been described in detail only in recent years.

The fate of the majority of the Felixmüller works confiscated as "degenerate" is uncertain; a large number must be considered destroyed and therefore lost. Yet individual pieces have resurfaced on repeated occasions. Among them is the heretofore completely unknown etching Pregnant Woman *(fig. 2), probably dating from 1920. After being confiscated, the print came into the possession of the art dealer Bernhard A. Böhmer, one of the "exploiters" of the confiscated art works authorised by the Propaganda Ministry. Around 1945 a number of Böhmer's Felixmüller prints somehow ended up in the collection of the music scholar Dr. Hans Erdmann (1911–1986) in Güstrow. It has been possible to assign some of them to their previous collections through provenance research initiated by their present owner – through inscriptions on the back or clear work titles in the list of the Reich Propaganda Ministry.* Pregnant Woman *probably came from the collection of the Staatliche Galerie in Stuttgart.*

3

More than 700 Felixmüller prints are known. Between 1947 and 1977 he pro-duced some 400, the majority of them woodcuts. Among them are scenes of rural life in Tautenhain and big-city life in Berlin, also the cycles The Artist's Year *and* I Saw and Carved in Wood *– "My art friends will recognise that in these woodcuts I am continuing my painting," wrote Felixmüller. He also made quantities of small-format occasional prints. These make up an altogether charming part of the artist's work, and one that found broad distribution but has hardly been recognised heretofore. Although these may not be as important as his early printmaking work, they repeatedly show the artist to be a master of the small format. With great narrative delight, Felixmüller fashioned dozens of New Year's greetings, grandchildren's birth*

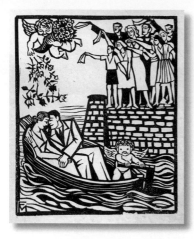

3a

3b

notices, wedding announcements and sons' changes of address – or simply labels for his beekeeping wife's honey jars. Any occasion was picture-worthy, and on these prints he lavished a love of detail: on Brigitte and Titus Felixmüller's wedding announcement a little Cupid steers the lovers' boat into the harbour of marriage. These works are also filled with humour, which he also frequently directed towards himself: on his New Year's card for 1954 Felixmüller is pictured racing behind a car driven by his wife, accompanied by his house pets, and with brush, palette, and even one of his pictures in his hands. Unlike his wife, the artist had no driver's licence, so it was only with her help that he could get to Halle an der Saale, suggested in the background. In these late works, though with completely different content, Felixmüller built upon earlier prints, including the graphics he produced for the journal Die Aktion, he was called upon to present the picture's message in an especially pointed way.

3a Brigitte and Titus Felixmüller's Wedding Announcement, 1951, woodcut
12 × 9.7 cm, P. A. Böckstiegel-Freundeskreis
3b New Year's Card for 1954 (Londa in the Car – Me Running Behind with the Animals), 1953, woodcut, 9.6 × 12 cm, P. A. Böckstiegel-Freundeskreis

SOURCES

PICTURE CREDITS

Photos were graciously placed at our disposal by the following museums and collections (identified by page numbers):

akg-images (29, 35, 44, 47). – akg-images / Erich Lessing (10). – Albertinum / GNM, Staatliche Kunstsammlungen Dresden, Hans-Peter Klut (Cover, 45). – Albertinum / GNM, Staatliche Kunstsammlungen Dresden, Jürgen Karpinski (42). – Anja Koschel (75). – Bernd Sinterhauf, Lindenau-Museum Altenburg (52). – Bertram Kober / PUNCTUM (34). – bpk / Nationalgalerie, SMB (13). – bpk / Kupferstichkabinett, SMB / Jörg P. Anders (27). – bpk / Nationalgalerie, SMB / Andres Kilger (19). – bpk / Nationalgalerie, SMB / Jörg P. Anders (22). – Christie's Images / Bridgeman Images (25). – David Riedel (77). – Guntram Thielsch (73). – Ingo Bustorf (14, 15, 16, 21, 24, 39, 40/41, 70). – Ketterer Kunst GmbH und Co. KG (17, 50/51). – Kunstmuseum Wiesbaden (32/33). – Lindenau-Museum Altenburg, Andreas Kemper (53). – LWL-Museum für Kunst und Kultur, Westfälisches Landesmuseum, Münster / Hanna Neander (2/3, 26). – Philipp Ottendörfer (4/5, 36/37). – Stiftung Schleswig-Holsteinische Landesmuseen Schloss Gottorf, Schleswig / Claudia Dannenberg (8). – Thomas Kersten (31, 43, 54). – The George Economou Collection, Athen (28).

The photos in the biography were graciously provided by the archives of the Peter August Böckstiegel museum and the family of the artist.

SOURCES

Excerpts have been drawn from the following literary sources (identified by page numbers):
Conrad Felixmüller, "Auch ein Denkmal" (1928), in: Gerhart Söhn (ed.), *von ihm – über ihn. Texte von und über Conrad Felixmüller*, Düsseldorf 1977, p. 96: 72.
Idem to Rudolf Feldmann, Letter from 26 September 1924, quoted from *Conrad Felixmüller an Rudolf Feldmann – Briefe an einen Kunstfreund (1924–1958)*, ed. David Riedel, exh. cat. Museum Peter August Böckstiegel, Werther 2021, p. 109f.: 72.
Otto Griebel, quoted from Peter Barth, *Conrad Felixmüller – Die Dresdner Jahre 1913–1933*, exh. cat. Galerie Remmert & Barth, Düsseldorf 1987, p. 103: 74.
Conrad Felixmüller, "Südfranzösische Reise" (1926), in: Söhn 1977 (loc. cit.), p. 92: 74.
Richard Müller, "Spiegelbilder des Verfalls in der Kunst", in: *Dresdner Anzeiger*, 23.9.1933: 75.
Conrad Felixmüller, quoted from G. H. Herzog (ed.), Felixmüller. *Legenden 1912–1976*, Tübingen 1977, p. 108: 76.

The quotes in the essay headings are taken from the following sources:
Conrad Felixmüller, "Über Kunst" (1925), in: Söhn 1977 (loc. cit.), p. 54: 11.
Idem, "Bekenntnis" (1915), in: ibid., p. 7: 12.
Idem, "Postulat" (1917), in: ibid., p. 9: 18.
Idem, quoted from Herzog 1977 (loc. cit.), p. 38: 20.
Printed leaflet by the Dresden Secession Group 1919 from March 1919, illustrated in: Fritz Löffler, Emilio Bertonati and Joachim Heusinger von Waldegg (eds.), *Dresdner Sezession 1919–1923*, exh. cat. Galleria del Levante, Munich 1977, n.p.: 23.
Conrad Felixmüller, quoted from exh. cat. Düsseldorf 1987 (loc. cit.), p. 76: 23.
Idem, "Als ich Max Liebermann zeichnete" (1926), in: Söhn 1977 (loc. cit.), p. 84: 30.
Idem to Hanns-Conon von der Gabelentz, Letter from 25 October 1935, quoted from Archiv für Bildende Kunst am Germanischen Nationalmuseum Nürnberg (ed.), Conrad Felixmüller. *Werke und Dokumente*, Klagenfurt 1981, p. 147: 48.
Idem to Titus Felixmüller, Letter from 15. July 1949, quoted from: ibid., p. 181: 53

Published by
Hirmer Verlag GmbH
Bayerstraße 57–59
80335 Munich
Germany

Cover: *Lovers against the Dresden Skyline* (detail),
1928, see p. 45
Double page 2/3: *Ruhr District II* (detail), 1920,
see p. 26
Double page 4/5: *Klotzsche Children's Home* (detail),
1924, see pp. 36/37

www.hirmerpublishers.com

TRANSLATION
Russell Stockman, Vermont

COPY-EDITING
Jane Michael, Munich

PROJECT MANAGEMENT
Tanja Bokelmann, Munich

GRAPHIC DESIGN AND PRODUCTION
Marion Blomeyer, Rainald Schwarz, Munich

PRE-PRESS AND REPRO
Reproline mediateam GmbH, Munich

PRINTING AND BINDING
Passavia Druckservice GmbH & Co. KG, Passau

Bibliographic information published by the Deutsche
Nationalbiliothek. The Deutsche Nationalbibliothek
lists this publication in the Deutsche National-
bibliografie; detailed bibliographic data is available
on the Internet at http://dnb.d-nb.de.

ISBN 978-3-7774-3824-5

Printed in Germany

THE GREAT MASTERS OF ART SERIES

ALREADY PUBLISHED

WILLEM DE KOONING
978-3-7774-3073-7

LYONEL FEININGER
978-3-7774-2974-8

CONRAD FELIXMÜLLER
978-3-7774-3824-5

PAUL GAUGUIN
978-3-7774-2854-3

RICHARD GERSTL
978-3-7774-2622-8

JOHANNES ITTEN
978-3-7774-3172-7

VASILY KANDINSKY
978-3-7774-2759-1

ERNST LUDWIG KIRCHNER
978-3-7774-2958-8

HENRI MATISSE
978-3-7774-2848-2

PAULA MODERSOHN-BECKER
978-3-7774-3489-6

LÁSZLÓ MOHOLY-NAGY
978-3-7774-3403-2

KOLOMAN MOSER
978-3-7774-3072-0

ALFONS MUCHA
978-3-7774-3488-9

EMIL NOLDE
978-3-7774-2774-4

PABLO PICASSO
978-3-7774-2757-7

HANS PURRMANN
978-3-7774-3679-1

EGON SCHIELE
978-3-7774-2852-9

FLORINE STETTHEIMER
978-3-7774-3632-6

VINCENT VAN GOGH
978-3-7774-2758-4

MARIANNE VON WEREFKIN
978-3-7774-3306-6

www.hirmerpublishers.com